THE PAPERS OF
WOODROW WILSON
VOLUME 13

SPONSORED BY THE WOODROW WILSON
FOUNDATION
AND PRINCETON UNIVERSITY

THE PAPERS OF
WOODROW
WILSON

CONTENTS AND INDEX, VOLUMES 1 TO 12

Volume 13 · 1856–1902

PRINCETON, NEW JERSEY
PRINCETON UNIVERSITY PRESS

1977

Note to scholars: Princeton University Press
subscribes to the Resolution on Permissions of
the Association of American University Presses,
defining what we regard as "fair use" of copy-
righted works. This Resolution, intended to en-
courage scholarly use of university press publi-
cations and to avoid unnecessary applications
for permission, is obtainable from the Press or
from the A.A.U.P. central office. Note, however,
that the scholarly apparatus, transcripts of
shorthand, and the texts of Wilson documents
as they appear in this volume are copyrighted,
and the usual rules about the use of copy-
righted materials apply.

Publication of this book has been aided by a
grant from the National Historical Publications
and Records Commission.

Printed in the United States of America
by Princeton University Press
Princeton, New Jersey

CONTENTS

EXPLANATORY NOTE

THE Table of Contents lists in one alphabet all the items printed in the first twelve volumes of this series under established editorial headings. Wilson's incoming and outgoing letters are listed in two alphabets. Editorial Notes are listed separately. Wilson's public addresses and lectures, and his writings are arranged chronologically, and there are sections for documentary material from the institutions where he taught.

Illustrations and text illustrations are listed separately.

The Index includes all persons and places mentioned substantively in the text and footnotes. All books, articles, pamphlets, and poems are indexed by author and title. Book titles appear in italics; quotation marks are omitted for articles and poems. An asterisk before an index reference designates major identification or other particular information. Page references to footnotes which carry a comma between the page number and the "n" cite both text and footnote; absence of the comma indicates reference to the footnote only. The present index supersedes the indexes of the earlier volumes in which many omissions have been discovered. Subjects are indexed selectively but not exhaustively; this is not intended to be a concordance to Wilson's writings.

The major work on the Table of Contents was done by Jean MacLachlan and Sylvia Fontijn. The Index is the work of M. Halsey Thomas. His colleagues join in paying tribute to him for his meticulous scholarship, broad learning, and unflagging zeal and dedication.

THE PAPERS OF
WOODROW WILSON
VOLUME 13

CONTENTS
FOR VOLUMES 1-12

CONTENTS 5

ILLUSTRATIONS

Illustrations appear in center section of each volume

Ellen Axson Wilson:
 as a young girl, **12;** later photograph, **3**
 about the time of her engagement, **4**
 in the 1890's, **7;11**
Janet Woodrow Wilson, **1**
Jessie Woodrow Wilson, **7**
Joseph R. Wilson, Jr., **2**
Joseph Ruggles Wilson:
 in 1866, **10**
 in 1870, 1874, **1**
 about 1888, **5**
Margaret Wilson, **7**
Marion Wilson, **1**
Woodrow Wilson: Portraits, Family Photographs, and Documents
 Birthplace, Staunton, Virginia, **1**
 Wilson house in Columbia, South Carolina, **1**
 Wilson about 1873, **6**
 Class picture, 1879, **1**
 The Alligators, 1879, **1**
 Evolution of Wilson's handwriting, **1**
 License to practice law in Georgia courts, **2**
 License to practice law in the United States Circuit Court, **2**
 Wilson, Atlanta lawyer, **2**
 First draft of "Government by Debate," **2**
 Extracts from letters of Ellen Louise Axson and Woodrow Wilson,
 4
 Marriage license, **4**
 Honeymoon cottage at Arden, North Carolina, **4**
 Wilson during Bryn Mawr period, **5**
 Wilson in 1889, **6**
 Marginal notes on Japanese Constitution of 1889, **6**
 Wilson, professor at College of New Jersey, **7**
 Wilson, 1893, **8**
 Typescript of *Division and Reunion*, **8**
 Letter that Wilson wrote with his left hand, **9**
 Wilson, Princeton Sesquicentennial Orator, **10**
 Manuscript of "Princeton in the Nation's Service," **10**
 Sesquicentennial academic procession, **10**
 Letter to Ellen Axson Wilson, showing bookplate, **11**
 Wilson at the rear of his home at 48 Steadman Street, **11**
 Wilson's home at 48 Steadman Street, **7**
 Wilson house on Library Place, **9,** floor plan, **9**
 Wilson at the time of his election as President of Princeton, **12**
 Samuel Ross Winans, **11**
 Caleb Thomas Winchester, **6**
 Hattie Woodrow, **2;** her album, **2**
 James Woodrow, **3**
 Hiram Woods, **3**

TEXT ILLUSTRATIONS

INDEX

Browning, William Clarence, 1:602n2, 608

Browning as a Philosophical and Religious Teacher (Jones), 11:134,n2

Brownson, Orestes Augustus, 1:645; 2:101,n5; 4:311; 6:569, 574, 610; 8:156, 157

Brubaker, Albert Philson, 8:482

Bruce, Philip Alexander, 9:318,n1; 10:283n4, 488n2; 12:328n2

Bruce, Wallace, 3:291

Bruce, William Cabell, 1:*579,n1, 584, n1, 586, 661; WW debate with, 1:643–46, 651,n1, 652–53, Editorial Note, 652; 4:590; 9:154

Bruck, Felix, 8:127

Brunel, Isambard Kingdom, 6:650

Brunet-Desbaines, Alfred-Louis, 9:552, n1

Brunner, Heinrich, 5:464; 6:569, 583; 8:127, 382, 421; 9:85, 88, 89

Bruns, Carl Georg, 6:569, 603; 8:127, 421; 9:71

Bruns, Henry Dickson, M.D., 11:397,n1, 422–23, 454; Mrs. (Katharine Logan), 11:397,n1, 454

Brunswick Hotel, New York City, 7:176; 8:412n2, 428

Brusa, Emilio, 6:250; 7:113n3

Brush, George de Forest, 3:336, 344, 346, 381, 395, 398, 436, 439, 463, 510–11, 515, 519, 520, 537, 615, 619; Mrs. (Mehitable Taylor Whelpley), 3:615

Bryan, Alfred Cookman, 8:138

Bryan, Francis Theodore, Jr., 1:196n1

Bryan, Joseph, 9:318n9; 10:488,n4

Bryan, William Jennings, 10:233, 309n2, 481n3; 12:79, 357

Bryan, William Swan Plumer, 1:32,n2, 39, 40, 41, 48, 49, 52, 53, 70

Bryan's store, Columbia, S.C., 6:416

Bryant, David Boyd, 1:32,n2, 40, 42, 43

Bryant (speech therapist), 8:357,n2

Bryant, William Cullen, 1:118; 2:12,n2, 449,n1; 8:154, 155; 12:40,n3

Bryant & Stratton Business College, 1:30, 53

Bryce, James, Viscount Bryce, 2:547,n2, 551, 556, 562, 566; 3:362, 622; 4:416, 420, 421, 495; invites WW to contribute to *The American Commonwealth*, 5:707–8, WW declines, 708–9; 6:4, 28, 31, 33, 44, 45, 58n1; WW review of *The American Commonwealth*, 60–76; 79, 137, 157, 166, 217, 218, 474, 477, 569, 599, 621; 7:89, 167, 283, 284, 291, 343–44, 370–71, 376, 379, 534; 8:23, 79, 80, 159, 193, 305, 414, 654, 658; 9:538, 542,n1; 10:39; 11:205, 217–18, 233–34; 12:242, 471

Bryn Mawr, Pa., Baptist parsonage, 5:501n1, 531n1, 594,n3; Bryn Mawr Presbyterian Church, 5:614,n1,2, 6:3,-16n2

Bryn Mawr College, 8:455,n4, 658; 9:7,

203; 10:95, 525; 12:468; Library, 1:xx, 5:409, 607n1; *see also* Wilson, Woodrow, BRYN MAWR COLLEGE

Bryn Mawr College Program, 4:217n

Bryn Mawr Home News, 5:615n2

Bryn Mawr School, Baltimore, 9:203,n5, 386n4; 10:126n4

Bryson, John H., 3:343,n2, 350n2

Buchan, John Comyn, 3d Earl of, 9:567; Lady Buchan (Isabella), 9:567

Buchanan, James, 2:410,n2; 8:150, 154; 11:319, 334, 336, 337, 338, 340, 347

Buchanan, W. M., 5:725

Buckingham, George Villiers, 1st Duke of, 6:576, 582

Buckingham, George Villiers, 2d Duke of, 1:98

Buckle, Henry Thomas, 2:131, 540n; 3:312–13,n1; 4:160; 5:449–50, 451; 6:317; 8:334

Buckley, James Monroe, 7:79,n3

Buckner, Aylett Hawes, 4:292

Buckner *v.* Finley, 8:515

Bucks County (Pa.) Historical Society, 1:xx

Budd, George William, 8:486n2

Büdinger, Max, 6:569, 576

Buena Vista, N.C., WW lot in, 7:248,n1; 8:14,n1

Buffalo, University of, Library, 1:xx

Bugbee, James McKellar, 6:494,n15

Bulkeley, Frances Hazen, 7:viii, 229n; 10:201n; 12:138n

Bulkley, Robert Johns, 12:286

Bull, The (hotel), Cambridge, England, 11:149, 150

Bulletin de la Société de Legislation Comparée, 3:391; 6:563

Bulletin of the New York Public Library, 11:126n2

Bullitt, Alexander Scott, 12:405,n1

Bullock, Joseph James, 2:360,n5

Bullock, Rufus Brown, 2:307

Bulmerincq, August von, 6:245, 281n5; 7:454,n1

Bulwer, William Henry Lytton Earle, Baron Dalling and Bulwer, 11:336

Bunce, John Thackray, 5:703,n2; 6:504, n26

Bundesstaat (Brie), 8:127

Bundle of Letters (James), 3:52–53, 59, 69–70

Bunsen, Christian Karl Josias, Baron von, 9:550

Bunting, Mrs., 3:384

Bunyan, John, 1:197; 9:546

Burchardi, Georg Christian, 6:569, 602

Burgess, John William, 5:219,n4, 288; 7:164, 274,n1, 475; WW marginal notes on his *Political Science and Comparative Constitutional Law*, 169–71, WW review, 164, 165, 166, text, 195–203; 8:193, 414; 9:238, 10:39, 263,n5; 12:79,n4

Burke, A. R., Mrs., 12:384

Elk *v.* Wilkins, **8:**559
Ella (nurse), **7:**469
Ellie, *see* Wilson, Ellen Axson
Elliot, Sir Gilbert, 1st Earl of Minto, **10:**416
Elliot, Jonathan, **6:**316, 682,n1
Elliott, Aaron Marshall, **9:**203,n2
Elliott, Edward Graham, **2:**417,n1; **6:**250,n11, 252; **11:***198,n1, 554,n1, 555, 556, 564–65; **12:**3, 26,n3, 31–32, 73–74, 85–86, 109–10, 119, 134, 136–37, 159, 160–61, 162, 194–95, 195, 369, 381–82; Mrs., *see* Axson, Margaret Randolph, sister of EAW
Elliott, James Johnston, **9:**95,n3, 279; **11:**555,n2,3, 556
Ellisland, nr. Dumfires, Scotland, **11:**148, 155–56
Ellsworth, Oliver, **4:**39; **10:**17, 20
Elmira College, **7:**345n2, 368; **8:**238n1; WW commencement address, **8:**275; *Sibyl,* **8:**275n
eloquence, Goldsmith on, **1:**102–3
Elsing, William Thaddeus, **1:**205,n4, 240, 249, 303, 306, 318, 320, 322, 323, 324, 339, 341, 347, 355, 356, 359, 360, 361, 364, 366, 375, 377, 380, 381, 400, 420, 425, 429, 437, 439, 444, 448, 449, 456, 463, 464; **10:**193n1
Elton, Charles Isaac, **8:**233
Ely, Margaret Hale, **1:**xxi; **4:**viii, 631n
Ely, Richard Theodore, **1:**15n, 15n20; **2:***448,n1, 453, 496–98, 506–8, 511, n2, 512–14, 515–16, 537n, 538n1,3, 544n, 552,n1, 569, 570, 586, 648, 660; **3:**25, 28,n2, 36,n4, 39, 49,n1, 50, 75, 77, 82, 112, 125, 152, 172, 196, 202, 209, 230, 324, 335n1, 339–40n, 342, n1, 344, 345n, 359, 362n1, 445, 446, 447n, 448n, 449n, 458–60, 553, 554, 569; **4:**8, 249, 269, 275, 294, 300, 301–3, 321, 341, 345, 391, 421–22, 548, 572, 580–81, 628–31, 679, 693, 738; **5:**19n1, 36, 39, 42, 43n, 55n, 98, 151, 154, 155, 242, 256, 263, 277, 350n, 455n1, 466, 558–59, 563n1, 602n, 667, 733; **6:**100, 134, 146, 153, 482, 523, 562, 630, 631, 635; **7:**102, 320, 379n1, 486n4; **8:**150, 153, 159; **9:**282; **12:**264–65, 402–3, 434; for projected volume, History of Political Economy in the United States (with WW and D.R. Dewey), *see* Wilson, Woodrow, WRITINGS; *Portrait, Vol.3;* Mrs. (Anna Morris Anderson), **3:**342n1
Ely, Robert Erskine, **12:**293,n1
Ely, Cambridgeshire, **9:**539, 551, 553; Ely Cathedral, **9:**564; WW in, **11:**149, 177, 178, 183, 198
Elyot, Sir Thomas, **1:**25
Emerson, Alfred, **3:**125,n7; **7:**247
Emerson, Ralph Waldo, **1:**481; **2:**459; **3:**397; **8:**369; **10:**20n2, 129, 326, 327, 341; **11:**255; **12:**351; Mrs. I (Ellen

Tucker), **2:**459; Mrs. II (Lidian Jackson), **2:**459
Emerton, Ephraim, **6:**478,n1
Emery, John Runkle, **12:**158
Emery, Matthew Gault, Jr., **1:**249,n5, 324, 363, 448, 449, 451, 456, 464, 472, 480n, 484; **5:**618,n2, 624
Emery (of Doubleday, Page & Co.), **11:**351
Eminent Chinese of the Ch'ing Period (ed. Hummel), **10:**74n2
Emma (Austen), **10:**176n3
Emma, Emmie, *see* Hoyt, Henry Francis, Mrs.
Emmet, John Duncan, M.D., **1:**588,n2
Emmott, George Henry, **6:**635,n1; **8:**508,n4; **9:**149, 166, 169; Mrs., **8:**508, n4; **9:**149, 166, 169
Emporia (Kansas) *Gazette,* **11:**258n4
Encouragement of Higher Education (Adams), **6:**66n2
Encyclopädie der in Deutschland geltenden Rechte (Bluhme), **8:**26
Encyclopädie der Staatswissenschaften (von Mohl), **8:**32
Encyclopädie des Wechselrechts (von Wächter), **8:**136
Encyclopædia Britannica, **2:**402, 405; **6:**286, 569, 570, 571, 575, 579; **7:**416, n19, 511; **8:**421, 638; **9:**44, 69, 563, **10:**416
Encyclopédia du droit (Roussel), **8:**133
Encyclopédie ou Dictionnaire raisonné des sciences, des arts et des métiers, par une société de gens de lettres (ed. Diderot and D'Alembert), **6:**225
Encyklopädie der Rechtswissenschaft in systematischer und alphabetischer Bearbeitung (ed. von Holtzendorff), **5:**464; **6:**287, 563, 569, 583; **7:**119, 249n1; **8:**125, 127, 129, 131, 421; **9:**71, 83, 85, 88, 92, 99
End of an Era (Wise), **11:**347
Endemann, William, **8:**27
Engel, Christian Lorenz Ernst, **5:**94
England: Local Government Act of 1888, **6:**117, 130, 131, 139, 149
England and America after Independence: A Short Examination of Their International Intercourse (Smith), **11:**115,n1
England under the Duke of Buckingham and Charles I, 1624–1628 (Gardiner), **6:**576
Englische Parlament in tausendjährigen Wandelungen vom 9. bis zum Ende des 19. Jahrhunderts (von Gneist), **5:**163, n1
Englische Verfassungsgeschichte (von Gneist), **6:**584; **7:**119
Englische Verwaltungsrecht der Gegenwart in Vergleichung mit dem deutschen Verwaltungswesen (von Gneist), **6:**584; **7:**119

Hahn, Friedrich von, **6:**585, 601
Haines, Elijah M., **4:**599, 623–24
Haines, Mrs., **5:**263
Haines, Oakley Philpotts, **11:**262,n3
Hakluyt, Richard, **6:**579, 580, 585, 586
Hakluyt Society, **6:**586
Haldane, Richard Burdon Haldane, 1st Viscount, **6:**596, 605
Hale, Edward, **6:**577, 586
Hale, Edward Everett, **5:**468,n2; **8:**495; **9:**118–19, 460, **10:**348n4
Hale, Edward Everett, Jr., **5:**468,n2; **9:**118–19
Hale, Sir Matthew, **8:**233, 383, 573, 574, 575, 576, 577, 652
Hale, William Bayard, **1:**21n, 22n, 56n1, 480n
Hale, William Gardner, **12:**79–80,n1, 90
Hale, William Harlan, **1:**xxii
Half-Hours with the Best Authors (ed. Knight), **1:**167, 168–70, 174, 175, 178, 179, 186n1, 187n1, 189, 192, 198n2,5, 199; **2:**402, 406
Half Moon, The (hotel), Exeter, Devon, **11:**151, 223
Halifax, George Montagu Dunk, 2d Earl of, **1:**95
Hall, Belle, **3:**382
Hall, Charles Cuthbert, **10:**366
Hall, Clayton Colman, **10:**345n1
Hall, Dr. (physician at Milledgeville Asylum), **3:**49,n9, 53, 176
Hall, Elizabeth, **9:**203
Hall, Granville Stanley, **1:**15n; **3:***73,n1, 205,n1, 207, 311, 335n1, 359, 382, 430,n1, 592; **5:**313,n1, 324; **12:**281
Hall, Jennie, **3:**382; **4:**456; **5:**282, 289
Hall, John, **3:**398,n4, 402
Hall, Laura (Mrs. Hiram Woods, Jr.), **3:**148,n3, 382; **4:**732,n2
Hall, Lyman Beecher, **8:**463n2; Mrs. (Carolyn Coffin Ladd) **8:***463,n2, 467, 475
Hall, Marshall, **1:**291
Hall, Mrs. (Eliza Leovy), **11:**395
Hall, Robert, **1:**169
Hall, Robert C., **3:**148n3
Hall, Thomas Cuming, **7:***614,n3; **8:**201, 586,n12; **11:**91,n3, 96
Hall, William Edward, **7:**291, 292, 379, 454,n2, 456; **8:**29; **9:**385n1
Hall, William Henry, **6:**119,n1
Hall of Fame for Great Americans, New York University, **11:**538,n1,2,3; **12:**27,n1,3
Hall *v.* De Cuir, **8:**544
Hall *v.* Wisconsin, **8:**551
Hallam, Henry, **1:**158; **2:**403, 406; **6:**314, 315; **7:**355
Halle-Wittenberg, University of, **11:**565n4; **12:**26n4, 30n1, 150–52
Hallet & Davis Co., **2:**90
Halliwell-Phillips, James Orchard, **11:**196,n3
Halls, *see* Princeton University:

American Whig Society and Cliosophic Society
Hals, Frans, **9:**509
Hälschner, Hugo, **8:**129, 132, 136
Halsey, Abram Woodruff, **1:**439,n1, 480, 545; **2:**118n1; **5:**711n; **6:**524; **8:**586,n4, 5; **10:**192, 193n1, 563,n2; **12:**193
Hamer, Philip May, **1:**xix
Hamerton, Philip Gilbert, **1:**530, 532,n1, 540; **2:**344n1, 351–52, 356–57, 389, n1, 400, 403, 406, 412, 488; **3:**393,n2, 471, 473; **4:**340,n1, 458, 594,n1; **5:**403, 422,n3, 428,n1, 544; **6:**135
Hamill, S.S., **2:**403, 406
Hamilton, Alexander, **1:**396, 443, 504; **2:**148n6, 149–52, 156n, 205n, 228, 240, 260n, 402, 404; **4:**21–22,n3, 24–25, 104, 143, 148, 166; **5:**17n, 494, 547, 696; **6:**316, 683; **7:**90, 201, 479; **8:**148, 188, 196, 355, 369–70, 547; **9:**158, 384; **10:**226, 228, 232, 463n2; **12:**216, 353, 361
Hamilton, Elizabeth, **8:**131
Hamilton, Elizabeth Porter, **4:**334, 497
Hamilton, George Porter, Jr., **1:**355,n1
Hamilton, Ida, **8:**389,n1, 392
Hamilton, James Alexander, **8:**153
Hamilton, Morris Robeson, **10:**348
Hamilton, Peter Joseph, **1:**480; **2:**82
Hamilton, Samuel Munce, **3:**523,n1, 568, 587–88, 592, 607, 614; **4:**225,n2, 334, 370, 497, 604, 622; Mrs. (Emily Porter), **4:**333,n2, 334, 365, 497, 524, 622, 667
Hamilton, Sinclair, **4:**334
Hamilton, Sir William, **1:**27; **2:**541n
Hamilton, William Augustus Porter, **4:**334
Hamilton, William Gerard, **1:**95; **8:**31, 326–27
Hamilton College, **1:**295, 344, 376
Hamlet (Shakespeare), **1:**442, 485; **2:**403, 408, 602, 607, 614; **3:**486, 632; **4:**187, 188; **8:**614,n1
Hamlin, Cyrus, **5:**3,n2
Hammond, A.S., **12:**366
Hammond, Jabez Delano, **8:**153
Hammond, Mrs. (of Savannah), **2:**613, 647
Hammond, Nathaniel Job, **2:**287n2, 312,n3, 314, 321, 371, 510, 663; **4:**180, n3
Hammond typewriters, *see* Wilson, Woodrow, TYPEWRITERS AND OFFICE EQUIPMENT
Hamner (of Baltimore), **3:**579
Hampden, John, **1:**125, 311, 327, 388, 407; **2:**238; **4:**117; **6:**178; **8:**350; **9:**289; **10:**23; **12:**218
Hampden-Sydney College, **8:**197–98, 212, 213, 225,n3, 272
Hampton (dentist in Rome, Ga.), **1:**297
Hampton, George McDuffie, **1:**602n2, 608

Heath, Charles, **1**:xxii

Heath, Daniel Collamore, and D.C. Heath & Co., **5**:99, 134, 147–48n, 149–50, 151, 156, 160, 161–62, 167, 171, 173, 220, 296, 305–8, 313, 319, 324–25, 384, 385, 389, 392, 650, 657, 659, 751, 768–69; **6**:129, 184, 216, 239, 311, 313–14, 319, 366, 367–68, 376, 377, 380, 392, 395–96, 396n1, 399, 409, 550, 687–88; **7**:70, 76–77, 172–73, 175, 239, 302–3; **8**:403n3, 446, 453, 475, 488, 499; **10**:185, 189–90, 324, 394, 398; **11**:53,n2; **12**:419

Heathen, The, *see* Lee, William Brewster

Heavenly Twins (Grand), **11**:67

Heckscher, August, **1**:vii, xii, xiv, xviii

Hedges, Job Elmer, **12**:96, 97n2, 107, 114

Heefner, Mark, **1**:xxii

Heeren, Arnold Hermann Ludwig, **6**:586, 595

Heffelfinger, Louis, **12**:265

Heffter, August Wilhelm, **7**:326

Hegel, Georg Wilhelm Friedrich, **1**:89; **3**:428; **4**:317,n1, 318; **5**:361; **6**:586, 587; **8**:129, 236

Hegel (Caird), **4**:319n1

Heidelberg, University of, **11**:564,n1; **12**:3, 85, 109–10, 119, 134, 136–37, 369

Heilers (New York friends of EAW), **3**:409, 425; **4**:327

Heimera, Rousseau Falls, Ont., **12**:147n2, 179n2

Heir Expectant (Harwood), **1**:150,n1

Held, Adolf, **6**:587, 597

Held, Joseph von, **8**:129

Helen, *see* Killough, Helen Porter

Helenhurst, home of James W. Bones, **2**:297,n1, 369

Helm, Lynn, **1**:324,n3, 381, 425

Helmer, Frederic Flagler, **11**:242, 243, 355

Helps, Sir Arthur, **10**:39

Helvétius, Claude Adrien, **2**:497

Hemphill, Charles Robert, **4**:332,n1, 517–18

Hemsley, John, Jr., **8**:65,n2

Hen, The, *see* Henderson, Robert Randolph

Henderson (seedsman), **9**:553

Henderson, George, **7**:209,n3; **8**:447n2

Henderson, Isaac, **2**:12,n2, 90n1

Henderson, Robert, **9**:404,n1

Henderson, Robert Randolph (The Hen), **1**:*270,n1, 271, 289, 293, 329, 386; **2**:148,n4; **4**:615, 731,n1; **5**:7n, 11; **9**:180; **10**:193n1, 317–18, 572, 578,n2, 579, 580, 582; **11**:118n2, 122–23; **12**:144, 412, 431, 433; Mrs. (Louisa S. Patterson), **10**:318; 580; **12**:144

Henderson, Theodore Sommers, **6**:45, 77, 78

Henderson, William A., **7**:548,n2, 552, 553, 561; **11**:496,n4; Mrs. (Minnie Brown), first cousin of EAW, **3**:306;

5:284,n1; **7**:538,n1, 548,n2, 552; **11**:496,n4

Henderson, William James, **1**:274,n1

Henderson *v.* Mayor of New York, **8**:543

Hendersonville, N.C., **11**:192, 212

Hendren, Samuel Rivers, **9**:147–48,n1

Hendrick, Burton Jesse, **9**:312n1; **11**:221n1

Hendricks, Thomas Andrews, **1**:147, 210

Hendrickson, George Lincoln, **6**:630,n3; **7**:222

Hengist, **7**:21

Hening, William Waller, **7**:312; **8**:85,n5

Henneman, John Bell, **8**:197,n2, 212; **9**:95–96, 163, 210, 218, **12**:425,n1

Henry, Carrie, **11**:390

Henry, Charles C., **11**:279n2

Henry, Dr., **10**:170,n1; Mrs., *see* Truehart, Alice Louise Hoyt

Henry, James Addison, **12**:422

Henry, (James) Bayard, **7**:378,n1, 443n, 445; **10**:334; **12**:200n1, 257n2, 297, 309, 315, 344, 374, 379–80, 380, 382, 383, 390, 393–94, 398, 401, 474n1; Mrs. (Jane Robeson), **10**:168,n2

Henry, P.W., **11**:96

Henry, Patrick, **1**:573, 637; **2**:239; **4**:118; **5**:398; **6**:316; **7**:367; **8**:347, 379, 380; **9**:267, 360,n2, 361, 370; **10**:22, 77,n2, 207, 208, 288; **11**:48; **12**:212, 468

Henry, Thomas Maxwell, **1**:199,n4, 545

Henry, William Wirt, **10**:77,n1, 209, 282,n1, 286; **11**:381

Henry I, **7**:42; **8**:566

Henry II, **7**:23, 30; **8**:564, 565, 566, 573, 578, 583; **9**:56, 81, 237

Henry II (Green), **7**:284, 398n16

Henry III, **7**:27, 31n; **8**:566, 572, 577

Henry IV (Shakespeare), **1**:341

Henry V, **12**:45, 221

Henry VI, **7**:26, 31

Henry VII, **10**:504

Henry VIII, **7**:30; **8**:107, 566; **10**:417

Henry Clay (Schurz), **5**:551; **7**:284

Hensell, Lawrence, **1**:31,n2, 48–49, 53

Hepburn, Andrew Dox, **4**:525,n1

Hepburn, James Curtis, **12**:421

Hepworth, Janice, **1**:xiii

Herbart, Johann Friedrich, **8**:129

Herbert, Edward, 1st Baron Herbert of Cherbury, **1**:169

Herbert, George, **1**:74n, 84n, 169; **8**:409, n1, 608,n7, 617; **9**:106,n3; **10**:134,n5

Herbert, Hilary Abner, **8**:162, 165, 167, 171, 174; **10**:112; **11**:446n2

Herbert B. Adams: Tributes of Friends, with a Bibliography of the Department of History, Politics, and Economics of the Johns Hopkins University, 1876–1901, **1**:15,n20; **7**:320n1; **12**:175n2, 265n1

Hermann, Carl (also Karl) Friedrich, **6**:587, 589; **12**:247

Hermann, Robert Achill Friedrich, Graf Hue de Grais, **6**:583, 585, 599

His Brother's Brother (Higginson), **11**:189n1

His Great Self (Harland), **9**:320n1

Hispanic Society of America, **1**:xx

Histiaeus of Miletus, **5**:30–31

Histoire de Colbert et de son administration (Clément), **6**:571, 598

Histoire de la civilisation française (Rambaud), **5**:44

Histoire de la littérature française (Nisard), **6**:581

Histoire de l'économie politique des anciens peuples. . . (du Mesnil-Marigny), **6**:575, 598

Histoire des états généraux de France; suivi d'un examen comparatif de ces assemblées et de parlements d'Angleterre (Rathery), **6**:581, 600, 607

Histoire des états généraux et des institutions représentatives en France (Thibaudeau), **8**:236

Histoire du droit civil de Rome et du droit français (Laferrière), **8**:234

Histoire du droit des gens et des relations internationales (Laurent), **6**:589, 596

Histoire du droit et des institutions politiques, civiles et judiciaires de l'Angleterre (Glasson), **8**:383

Histoire du droit français, précédée d'une Introduction sur le droit civil de Rome (Laferrière), **6**:580, 589

Histoire philosophique du règne de Louis XV (de Tocqueville), **9**:375

Histoire politique interne de la Belgique (Poullet), **7**:181

Historia Animalium (Aristotle), **1**:78

Historian's World: Selections from the Correspondence of John Franklin Jameson (Donnan and Stock), **5**:548n2; **6**:59n2; **7**:239n1

Historic Towns of the Middle States (Powell), **8**:496n4

Historic Towns of New England (Powell), **8**:496n4

Historic Towns of the Southern States (Powell), **8**:496n4

Historic Towns of the Western States (Powell), **8**:496n4

Historic Waterways (Thwaites), **6**:383

Historical and Geographical Notes on the Earliest Discoveries in America, 1453–1530 (Stevens), **6**:566, 608

Historical Atlas (Labberton), **8**:154, 155, 489,n1

Historical Collections of Louisiana and Florida (French), **6**:579

Historical Collections of Virginia (Howe), **9**:332,n2

Historical Essays (Freeman), **6**:581

Historical Geography of the British Colonies (Lucas), **11**:211,n2

Historical Geography of the United States (MacCoun), **8**:152, 153, 154, 155

Historical Introduction to the Private Law of Rome (Muirhead), **6**:594, 603

Historical Magazine, **2**:648

Historical Researches into the Politics, Intercourse, and Trade of the Principal Nations of Antiquity (Heeren), **6**:586, 595

Historical Scholarship in the United States, 1876–1901: As Revealed in the Correspondence of Herbert B. Adams (ed. Holt), **11**:53n2

Historical Seminary, *see* Johns Hopkins University, Seminary of Historical and Political Science

Historical Sketch of Social Science (Villard), **10**:537n2

Historical Sketches of Statesmen who Flourished in the Time of George III, together with Remarks on the French Revolution (Brougham), **1**:85n, 114n1, 201; **6**:317

Histories of the French Revolution (Harrison), **6**:317

History, essay by Macaulay, **11**:342

history, philosophy of, titles on, **6**:587

History, Principles and Practice of Banking (Gilbart), **8**:233

history, teaching of, **8**:61f

History and Analysis of the Commission and City Manager Plans of Municipal Government in the United States (Chang), **9**:230n2

History and Antiquities of the Doric Race (Müller), **6**:585, 594

History and Form of Offices in England (von Gneist), **6**:584

History and Origin of Representative Government in Europe (Guizot), **7**:284

History and Practice of the High Court of Chancery (Gilbert), **8**:233

History and Principles of the Civil Law of Rome (Amos), **6**:567, 602; **9**:85, 86

History of American Currency (Sumner), **8**:151, 153

History of American Politics (Johnston), **2**:558,n1; **6**:216,n1, 316, 431; **7**:284; **8**:150, 152, 153, 154, 155, 156; **11**:346

History of an Expedition Against Fort Du Quesne, in 1755; under Major-General Edward Braddock (ed. Sargent), **9**:332,n4, 334

History of Antiquity (Duncker), **6**:575, 596

History of British India (Mill), **6**:588, 593

History of Brown University, 1764–1914 (Bronson), **10**:309n2

History of Canon Law in Conjunction with Other Branches of Jurisprudence (Dodd), **8**:233

History of Civilization in England (Buckle), **2**:131, 540n; **3**:313,n1; **6**:317

History of Cornell (Bishop), **10**:42n2

History of England (von Ranke), **6**:315

History of England from the Accession of James the Second (Macaulay), **1**:86n, 109, 132, 133–34, 135, 136, 137, 138,

infant baptism, **8**:119, 121

Inferno (Dante), **1**:221, 222, 229, 442; **9**:112

Influence of Party upon Legislation in England and America (Lowell), **10**:334; **11**:123,n1

Influence of the Roman Law on the Law of England (Scrutton), **5**:634n; **6**:601, 605; **8**:134

Influence of Woodrow Wilson on Frederick Jackson Turner (Stephenson), **6**:58n1; **8**:61n1; **9**:274,n3

Ingelow, Jean, **2**:452, 569, 599; **3**:76,n3, 100, 106; **7**:543n1; **10**:393

Ingersoll, Robert Green, **2**:95, 103; **11**:188n3

Ingle, Edward, **2**:447n3, 648, 661; **3**:8–9, 10, 137, 199,n2, 203; **12**:94–95,n1,2, 102–3, 163, 164, 171, 440

Ingle, Richard, **12**:94–95, 102, 163, 164, 171

Inglis, **3**:142

Ingraham, Joseph Holt, **3**:47,n4

Ingram, John Kells, **7**:291

Innocent III, Pope, **1**:389

Inquirer (London), **10**:341,n2, 429, 430

Inquiry into the Law of Negro Slavery in the United States (Cobb), **11**:347

Inquiry into the Nature and Causes of the Wealth of Nations (Smith), **2**:497, 538, 540–41n; **5**:448, 449, 450–51; **7**:439

Inquiry into the Nature of the Wealth of Nations (ed. Rogers), **2**:540n

Inquiry into the Origin and Course of Political Parties in the United States (Van Buren), **8**:152, 153

Inquiry into the Origin of the Laws and Political Institutions of Modern Europe, Particularly of Those of England (Spence), **8**:236

Inquiry into the Present State of Polite Learning in Europe (Goldsmith), **1**:214

Inquiry into the Rise and Growth of the Royal Prerogative in England (Allen), **8**:230

Installation of a Bishop, **2**:97,n1

Institute of Arts and Letters, *see* National Institute of Arts and Letters

Institute of Civics, *See* American Institute of Civics

Institutes and History of Roman Private Law (Salkowski), **8**:236

Institutes coutumières (Loisel), **9**:91

Institutes of Common and Statute Law (Minor), **1**:583–84,n1; **2**:104–5; **7**:293

Institutes of English Adjective Law (Procedure in Court), (Nasmith), **8**:235

Institutes of Justinian illustrated by English Law (Williams), **6**:601, 610; **8**:136

Institutes of Roman Law (Sohm), **7**:293; **8**:30, 421; **11**:565n2

Institutes of the Christian Religion (Calvin), **5**:490,n1

Institutes of the Law of Nations (Lorimer), **7**:595

Institutionen des römischen Rechts (Sohm), **8**:135

Institutionen und Geschichte des römischen Rechts (Kuntze), **6**:589, 602

Institutions municipales et provinciales comparées (Ferron), **6**:86n1, 565, 578, 581; **7**:120

Institutions of the English Government; being an Account of the Constitution, Powers, and Procedures of the Legislative, Judicial and Administrative Departments (Cox), **6**:565, 573; **8**:232

Intellectual Life (Hamerton), **2**:344n1, 351–52, 356–57, 403, 406; **3**:393,n2; **4**:340,n1, 458, 594,n1

intemperance, EAW on, **3**:93

Inter-Collegiate Athletic Association, field-meeting, Mott Haven, N.Y., May 18, 1878, **1**:378–79

Inter-Collegiate Literary Association, **1**:*210,n2, 238–39,n1,2, 260–62, 294–96, 344, 376, 414, 418–40, 444–45, 463

Inter-Collegiate Oratorical Contest, **1**:238, 444

Intercourse Between the United States and Japan: An Historical Sketch (Nitobe), **8**:234

Interest of America in Sea Power, Present and Future (Mahan), **10**:572,n4

International (Chicago), **9**:436n1, 568,n9; **10**:166,n5,6

International Bimetallism (Laveleye), **3**:460n

International Congress of Education, *Proceedings,* **8**:285n1, 292

International Congress of History, **11**:381

International Cyclopedia, **12**:87,n2

international law, WW notes on, **1**:594–96

International Law (Hall), *see Treatise on International Law*

International Law (Maine), **7**:595

International Law: Private and Criminal (von Bar), **8**:231

International Law and International Relations (Stephen), **8**:236

International Review, **1**:143,n1, 186,n1, 464n, 476,n1, 484, 489, 490, 491, 510n, 510, 512, 514, 540, 556n2, 574n, 575, 584, 677, 686; **2**:25,n3, 31n, 48, 153n, 244n, 325, 335, 338, 567; **3**:17n, 36n1, 2, 159,n2, 450; **4**:299, 414; **9**:155, 158n4; **10**:40; **12**:470

Internationale Private- und Strafrecht (von Bar), **8**:126

Internationale Strafrecht (Rohland), **8**:133

Interoceanic Canal and the Monroe Doctrine (Williams), **2**:403, 407

inter-racial marriages, **3**:523–24, 532

Jacobus, Melancthon Williams (Princeton 1834), **1**:220,n1

Jacobus, Melancthon Williams (Princeton 1877), **10**:70n1; **12**:*400,n2, 401

Jagemann, Hans Carl Günther von, **5**:146,n1, 649, 656, 723–24, 727; **10**:101,n1; Mrs. (Frances A. Whitman), **10**:101

Jahrbücher für die Dogmatik des heutigen römischen und deutschen Privatrechts, **8**:126, 129, 130

Jakeman, Carolyn E., **8**:viii

James, Abel, **12**:168

James, Darwin Rush, Jr., **9**:95,n3

James, Edmund James, **3**:135,n1; **5**:13, n2, 14, 134, 412,n1, 419, 423, 424, 427–28; **6**:45, 82n1; **7**:73, 96–97, 106–7, 203, 209n1, 246n1; **8**:482, 495; **9**:170n1, 230n2, 312; **10**:500; Mrs. (Anna Margarethe Lange), **7**:203; **9**:170,n1

James, George Francis, **7**:246,n1

James, Henry, **3**:52–53, 59, 69–70

James, Samuel Humphreys, **2**:43,n3

James II, **1**:133, 135, 244; **2**:255; **7**:29, 43

James Lee's Wife (Browning), **3**:386,n2

James Monroe (Gilman), **2**:402, 404; **8**:152

James Sprunt Historical Monographs, **12**:75n5

Jameson, Alexander F., Mrs., **12**:206–7

Jameson, James Walker, **12**:99

Jameson, John, **6**:400; Mrs. (Mariett Thompson), **6**:400, 619

Jameson, John Alexander, **6**:373,n1; **7**:329,n5, 330, 331, 336, 341,n10, 351, n3

Jameson, John Franklin, **1**:15; **2**:*448, n2, 552,n1, 648, 660; **3**:362, 445, 569; **5**:viii, 15, 507,n1, 546–48, 584, 633–34, 667–68, 759–60; **6**:9–10, 10–11, 12, 17–18, 22, 23–24, 27–28, 29–30, 47, 58–59, 59n2, 140–41, 145, 146, 147–48, 156–57, 251n, 321–22, 323n2, 379, 380–81, 385–86, 398–400, 407, 410, 420n2, 426–27, 429, 546–48, 555–57, 618–19, 621–22, 622–23, 625, 626, 628, 629, 631, 634–35, 639–40, 643–44, 673n4, 673–74, 678–79, 682, 684; **7**:226–28, 238–39, 270–71, 273–74, 371–72, 442–43, 444, 470n; **8**:23–24, 142n, 143n, 181,n4; **9**:29n8, 157, 326n, 348–49, 499; **10**:72, 99, 463, 484; **11**:92, 431, 447,n3; **12**:282, 427–28; *Portrait, Vols. 3 and 8;* Mrs. (Sara Elizabeth Elwell), **8**:23,n1, 24; **11**:92, 431

Jamsie, *see* Woodrow, James Hamilton

Janentzky's, **5**:282

Janie, *see* Chandler, Samuel, Mrs.

Japan: constitution, **6**:168, WW on, 169–72, promulgation of, at Johns Hopkins, 172–73

Jarvis, Thomas Jordan, **3**:275,n2, 276

Jay, John, **6**:316; **8**:529

Jeaffreson, John Gordy, **2**:580,n3

Jean Ingelow Birthday Book, **10**:393,n2

Jeanie, *see* Wilson, Joseph Ruggles, Mrs.

Jeff, *see* Virginia, University of, Jefferson Society

Jefferson, Joseph, **12**:57

Jefferson, Thomas, **1**:396, 648; **2**:402, 404; **4**:34, 111, 115, 139; **5**:412; **6**:34, 316, 630, 683; **8**:196, 369, 373–74; **9**:158, 360, 506, 526; **10**:119, 227, 232, 283n4, 292, 335, 501; **11**:258, 306; **12**:13, 46, 215, 216, 268, 276, 328, 357

Jefferson Davis, Ex-President of the Confederate States: A Memoir (Davis), **11**:347

Jefferson Davis and the Lost Cause, **5**:209n1

Jefferson Society, *see* Virginia, University of, Jefferson Society

Jeffrey, Francis, Lord Jeffrey, **1**:86n, 91, 104, 107, 108, 120, 167, 173, 179, 186, 195,n2, 196, 197; **5**:640; **6**:347, 352; **10**:136

Jeffreys, George, 1st Baron Jeffreys, **11**:224

Jellinek, Adolf, **6**:170n2

Jellinek, Georg, **6**:*170,n2, 287, 434, 441, 468,n1, 469n1, 470, 483, 505,n28, 508, 513, 515n58, 519n61; **7**:90, 119, 132, 133, 435; **8**:129, 130; **9**:22, 32, 33, 34, 99; **10**:476; **11**:564,n1; **12**:85,n2, 109, 134,136–37,n1, 161, 162, 369, 382

Jencken, Henry Diederich, **8**:236; **9**:93

Jenkins, Charles Jones, **2**:307

Jenkins, Howard M., **2**:63n1, 366

Jenkins, James Caldwell, **2**:96,n7

Jenkins, John Benson, **2**:95, 103,n1

Jenkins, John Evan, **6**:45, 78

Jenkins, John Stilwell, **12**:194

Jenkins, Mr., **5**:749

Jenkins, Mrs. (New York friend of EAW), **3**:397, 409, 425, 510, 534

Jenkins, Robert Charles, **6**:574

Jenkins *v.* Culpeper Co., **7**:578n; **8**:536

Jenks, Jeremiah Whipple, **6**:320n1; **8**:611n1; **10**:573; **11**:127,n1, 533

Jennie (servant), **6**:94, 100, 123

Jennings, George Henry, **2**:403, 407

Jennings, Miss (of Baltimore), **3**:566, 567

Jephson, Henry Lorenzo, **7**:440n1; **8**:31–33, 601

Jennings, George Henry, **2**:403, 407

Jennings, Miss (of Baltimore), **3**:566, 567

Jephson, Henry Lorenzo, **7**:440n1; **8**:31–33, 601

Jersey City: Jersey City Club, **12**:267; Lincoln Association, **12**:267, 270; Public Library, **1**:xx; WW speech, **12**:267–71

Jersey Journal (Jersey City), **12**:271n2

Jerusalem Delivered (Tasso), **1**:115

Jervas, Charles, **1**:86n

Jervis, William Henley, **5**:409

Jess, *see* Wilson, Jessie Woodrow

Low, Seth, **5:**708, **6:**27,n1, 57,n1, 61, 473,n1, 521; **7:**192,n1, 372n3; **8:**192, n1; **9:**214, 220,n1; **10:**61n1, 260,n2, 263, 348n4, 494; **11:**389; **12:**194n3, 312n1

Lowdermilk, W. H. & Co., **10:**395

Lowe, Robert, Viscount Sherbrooke, **1:**354n, 615, 637

Lowell, Abbott Lawrence, **5:**107n, 117n4, *169,n2, 173, 174; **9:**16, 17, 18, 99; **10:**39, 334, 476; **11:**19, 123,n1, 211

Lowell, Augustus, **5:**169

Lowell, James Russell, **1:**481; **2:**239; **4:**172; **5:**584,n1; **6:**178,n2, 650, 671n13; **8:**380, **9:**203, 270,n2, 288,n2, 444; **10:**100, 257; **11:**220; **12:**358,n7

Lowell Institute and Lectures, **5:**169, **6:**593

Lowndes, Lloyd, **10:**582,n3

Lowrie, Matthew, **10:**536n1

Lowrie, Reuben, **1:**382,n2

Lubbock, Sir John, **6:**459

Lucan (Marcus Annaeus Lucanus), **1:**90

Lucas, Charles Prestwood, **11:**211,n2

Luce, Cyrus Gray, **5:**548,n2

Luce, Matthew, **11:**302, 576,n2

Luchaire, Achille, **12:**250

Lucian, **1:**90

Lucinda (servant), **6:**694

Lucretius (Titus Lucretius Carus), **1:**79; **9:**554,n5

Lucretius (Mallock), **9:**554,n5

Lucretius (Tennyson), **9:**554

Lucy, *see* Fisher, Lucy B.

Lucy, Sir Thomas, **1:**156n1

Lucy Cobb School, Athens, Ga., **9:**521n3

Lumholtz expedition in Central America, **7:**176

Lunt, Edward Clark, **5:**563,n1, 564, 586, n1, 739, 740, 741, 745,n4, 748

Lunt, George, **11:**347

Lupton, Jonah W., **10:**563,n5, 565

Lupton, Julia, **6:**328,n2, 329

Luria: A Tragedy (Browning), **7:**358,n9; **11:**124

Lurton, Horace Harmon, **9:**282,n2, 284

Lurton, Mary (Mrs. Robert Johnston Finley), **9:**282, 284,n1

Lusk, William Thompson, M.D., **6:**375, n2

Lustkandl, Wenzel, **6:**572, 590, 592

Luther, Martin, **1:**125; **2:**649; **3:**441; **5:**441, 487–88; **6:**265; **8:**506; **10:**514

Luther *v.* Borden, **7:**514; **8:**541

Luton, Bedfordshire, **9:**547

Lyall, Sir Alfred Comyn, **6:**592; **10:**455; **12:**481, 483, 485

Lycidas (Milton), **9:**545,n6

Lycurgus, **1:**209

Lyle, M. G., **9:**442,n1

Lynchburg (Va.) *News,* **10:**483

Lynde, Charles Rollin, **1:**145n1

Lynde, Rollin Harper, **10:**529, 530

Lynde Debate, see *Princeton University, Lynde Debate*

Lyon, Peter, **11:**204n1, 221n1

Lyons, Lulie, **10:**305,n1, 385,n4, 389–90, 400; **11:**48,n2, 56

Lyrical Ballads (Wordsworth and Coleridge), **6:**348

Lytton, Edward George Earle Lytton Bulwer-Lytton, 1st Baron, **1:**84n, 86n, 613; **6:**336, 657,n9

Mabie, Hamilton Wright, **8:**495,n4; **10:**348,n1

Mac, *see* Dubose, McNeely, Sr.

McAdoo, Eleanor Wilson (Mrs. William Gibbs McAdoo), *see* Wilson, Eleanor Randolph

McAdoo, Mary Faith (Mrs. Donald Wilson Thackwell), **2:**85n

MacAlister, James, **7:**164,n3

McAlpin, Charles Williston, **10:**270n1; **12:**159–60,n1, 160, 161–62, 370, 375–76, 378, 380

MacArthur, James, **11:**351,n2

Macaulay, Margaret, **2:**279

Macaulay, Thomas Babington, 1st Baron Macaulay, **1:**72, 86n, 90, 98, 99, 106, 107–8, 112, 128, 132, 133–34, 135, 136, 137, 138, 139–40, 146, 147, 148, 149, 151, 152, 153, 154, 155, 156, 156n1, 157, 158, 159, 160, 162, 163, 164, 166, 182, 186, 187, 192, 197, 203, 204, 271, 283, 339, 341, 386, 442, 565, 625; **2:**41, 110n2, 238, 279, 327, 402, 403, 406, 408, 659; **3:**70; **4:**117, 458; **5:**478; **6:**314, 315, 338, 348; **9:**107, 293, 296–97, 300, 549; **10:**136; **11:**542, 548, 549, 550; **12:**61, 144n1

Macaulay, Zachary, **1:**107; Mrs. (Selina Mills), **1:**107

Macaulay (Morison), **2:**110n2, 402, 406

Macbeth (Shakespeare), **2:**403, 408; **4:**184

McBride, Katharine, **3:**vii, 518n; **4:**viii; **5:**viii

McCabe, William Gordon, **10:**285,n1

McCain, Charles R., **8:**207n

McCain, John Irenaeus, **8:***180,n1, 202–3, 207

McCall, Samuel Walker, **11:**446n2

McCammon, Joseph Kay, **9:**191,n2, 192; **10:**386

McCarter, Robert Harris (Bob; Pomp), **1:**13n, *132,n3, 140–41, 144, 145, 146, 150, 152, 154, 159–60, 162, 163–65, 178–79, 182–83, 192, 193, 196, 214, 216, 217, 240, 249, 253, 256, 263, 264n1, 269, 270, 278, 282–83, 283–84, 285,n3, 289, 292, 294, 296, 298, 303, 306, 314, 318, 320, 321, 322, 324, 339, 340, 341, 347, 356, 359, 362, 363, 364, 365, 366, 375, 377, 380, 381, 383, n1, 385, 393–94, 400, 412n1, 420, 425, 435, 436, 448, 456, 458, 463, 464, 480, 489; **4:**731,n1; **5:**767,n2; **6:**431, 480,n1; **9:**276; **10:**193n1

PRINCETON UNIVERSITY

Original name, from October 22, 1746 to October 22, 1896: College of New Jersey

WOODROW WILSON

I

II

———

I

BOYHOOD

Father records birth of Thomas Woodrow Wilson in family Bible, **1**:3; mother describes him as healthy, beautiful baby, 7; mother recalls birth about midnight of December 28, 1856, but "we do not know whether it was a little after midnight or before," 332–33; Wilson's Imaginary World, Editorial Note, **1**:20–22n; 24–25, 28, 43–44, 54–56; joins church, **1**:22–23; boyhood residence, **12**:440,n2

DAVIDSON COLLEGE

1873/74

student notebooks, **1**:25–26, 30, 36, 37, 53; course at Davidson College 1873/74, 26–28; Old Chambers, **1**:26n1, 67n1; clothes brought to college, **1**:30–31; Eumenean Society, WW activities in, 31,n1,2, 32, 37, 40, 41, 42, 43, 46, 49, 50, 51, 52, 53, 62; football nines, 47; WW grades, 67n1; honorable dismissal, 67; Davidson College mentioned, 29–30, 146, 456

PRINCETON STUDENT

Sept. 1875—June 1879

expenses, **1**:73–74, 80–83
American Whig Society: activities in, **1**:75, 78, 136,n1, 137, 142, 144, 145, 197, 202, 210, 214, 216, 217, 218, 219, 224, 240; 2d prize in Sophomore Oratorical Contest, 250n1; 251, 253, 254, 269, 292, 293, 296, 302, 316, 319, 321, 324, 328, 355, 377, 378, 380–81,n1, 382, 425, 435, 477
classroom notebooks, Editorial Note, **1**:75–76; course readings, **1**:78; subjects for essays, **1**:78–80
The Princetonian, **1**:83,n5, 130n, 215;

Woodrow Wilson, Princeton Professor,
cont.
12:470,n4; address at mass meeting in
the interest of Whig and Clio Halls,
Oct. 12, 1900, notes, 23, news report,
24; proposed sabbatical for 1901/02,
27–28, 51, 68, 74, 83, 89, 104, 130;
presentation of John Hay for LL.D.
degree at convocation, Oct. 20, 1900,
28,n1,2; "The Principles of Rectitude,"
address to Philadelphian Society, Nov.
15, 1900, announcement, 33, notes,
33–34, news report, 34; unable to meet
classes: inflamed throat, 44; WW
classes suspended during absence at
the south, 80; member of committee of
American Whig Society to abrogate
treaty with Cliosophic Society on
recruiting, 96–97,n2; response to
toast, "Princeton University," at *Daily
Princetonian* banquet, Princeton Inn,
March 1, 1901, news report, 100; judge
of preliminary trials for debate with
Yale, March 30, 1901, 100; speech at
Whig Hall smoker, March 1901, men-
tioned, 108; address on de Tocqueville
before Monday Night Club, March 18,
1901, news report, 111; introduction of
Grover Cleveland as Stafford Little
lecturer, Alexander Hall, March 27,
1901, 114–15,n1,2, 116; judge in final
trials for Harvard debate of May 10,
1901, 132; response to toast, "The
College Man in Journalism," at
University Press Club banquet,
Princeton Inn, April 30, 1901, news
notice, 138, notes, 139; address on
Gladstone to Philadelphian Society,
May 2, 1901, news report, 139–40;
member of faculty committee to ap-
pear before and confer with Trustees if
required, 155, 156, 205,n1, 286, 287,
309, 315, 398; presents candidates for
honorary degrees at Commencement,
1901, 158; appointed to faculty com-
mittee on the Graduate School, 185,
appears before Trustees, 191, 192; re-
marks at a special convocation follow-
ing the assassination of President Mc-
Kinley, Alexander Hall, Sept. 19,
1901, text, 185–87; delegate to 25th
anniversary of the founding of Johns
Hopkins University and inauguration
of President Ira Remsen, 256; "The
Christian in Public Life," talk before
Philadelphian Society, Feb. 20, 1902,
notes, 273, news report, 273–74;
"Princeton Men in Public Life," talk at
Daily Princetonian dinner, Princeton
Inn, March 4, 1902, notes, 285, news
report, 285–86; conducts vesper
service in Marquand Chapel, March 9,
1902, notice, 286, notes, 286–87; ad-
dresses nocturnal celebration follow-
ing debating victory over Harvard,
March 26, 1902, mentioned, 312; "A
Lawyer with a Style [Sir Henry

Woodrow Wilson, Princeton Professor,
cont.
Maine]" (printed 1898), read to Mon-
day Night Club, April 14, 1902, news
report, 330–31; "The Value of *The
Nassau Literary Magazine,*" remarks
at the annual Lit banquet, Princeton
Inn, May 12, 1902, mentioned, 369;
presents candidates for LL.D. and
Hon. A.M. at Commencement, 1902,
370, 375–76, 378, 380; memorandum
on proposed changes in the cur-
riculum, 391–92; remarks at alumni
luncheon, June 10, 1902, text, 420–21

NEW YORK LAW SCHOOL

annual course of lectures (1892–1897);
Editorial Note, Wilson's Lectures at
New York Law School, **7:**470–72;
report of a lecture, 472–79; lectures
mentioned, 467, 468, 470, 480, 485,
490, 492, 494, 497, 500, 502, 505, 506,
519, 531, 537, 538, 549, 551, 563, 567,
582, 584, 587, 588; lecture on
sovereignty and nature of govern-
ment, Mar. 1892, text, 512–19; lec-
tures on Constitutional Law, Apr.
1893, mentioned, **8:**182,n1, 405, 569,-
n1; announcement of WW and other
special lecturers, 581; WW ends an-
nual course, **10:**368, 369–70; lectures
mentioned, 389, 497

THE PRINCETON PRESIDENCY
See also main entry

Princeton University
candidacy mentioned, **12:**374n4, 380,
390,n2
involvement in Patton retirement, 288–
89, 297, 302, 304, 305, 310–11, 312–
13, 314, 315, 317–18, 320, 321–23,
326, 330, 339, 340, 341, 343, 345, 346,
364
nominated for President, 401
elected 13th President by unanimous
vote of Trustees, June 9, 1902, 401;
vote mentioned, 457
notification of election, and acceptance,
402
remarks at alumni luncheon, June 10,
420–21
letters of congratulation from Samuel
Alexander, 455–56,n1; Daniel Moreau
Barringer, 430; A. Elizabeth Wilson
Begges, 414,n1; Sarah Baxter Bird,
437; Alexander Scott Bullitt, 405,n1;
Jesse Benedict Carter, 466–
67; Jabez Lamar Monroe Curry, 448,
n1; Frederick Morgan Davenport,
442–43,n1; Alfred Lewis Dennis, Jr.,
403; Samuel Bayard Dod, 457–58,n1;
Franklin Woolman D'Olier, 452–53,
n1; Edith Duer, 409,n1; William
Archibald Dunning, 403; Edward

PUBLIC ADDRESSES AND LECTURES

II

NAME

BIOGRAPHY

APPEARANCE

End of Woodrow Wilson entry